An opinic

C000279960

EAST
LONDON

Second edition

Text by
SONYA BARBER

Photography by
CHARLOTTE SCHREIBER

INFORMATION IS DEAD.
LONG LIVE OPINION.

This is our updated guide to East London containing the best places to eat, shop, drink and enjoy in Hackney and beyond – outrageously skewed to our book-loving, gallery-visiting, dog-walking, food-munching tastes. We've added 23 new places and taken out 14. East London changes daily, that's why we love it.

We want to direct you to the kind of places we'd send our friends to visit. Not because they are cool, or new, but because they are great. This is our opinion. We don't apologise.

How dare we? Because we live here, we work here and we make books about East London. And because, in a world of absolutely-everything-is-available what matters is well-informed opinion, not dry data and facts. OK … our grandfather was not born here. But nor was yours. (Apologies if he was.)

East London is now known world-over as a creative hotspot. But with that comes a slightly self-conscious hipster vibe. Do we find gentrification uncomfortable? Often. Do we like a barista's beard dipping into our oat milk cappuccino? Never. But do we love the ever-changing food, shops and creativity? Always. Oh, the contradiction... these are the places we love.

Ann and Martin
Founders, Hoxton Mini Press

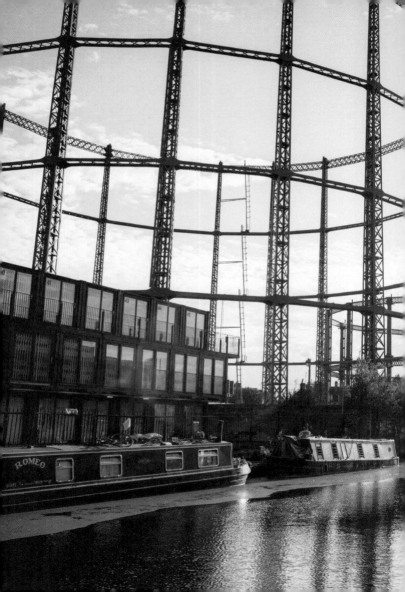

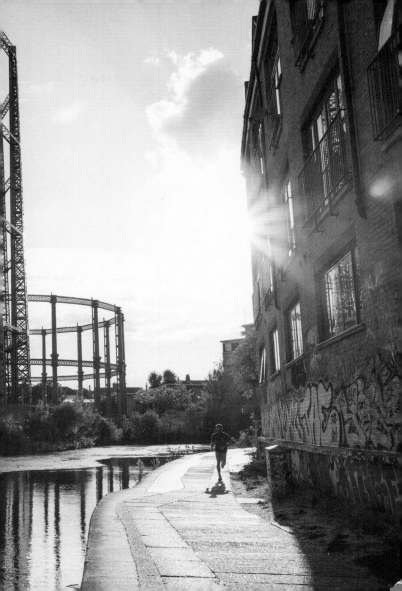

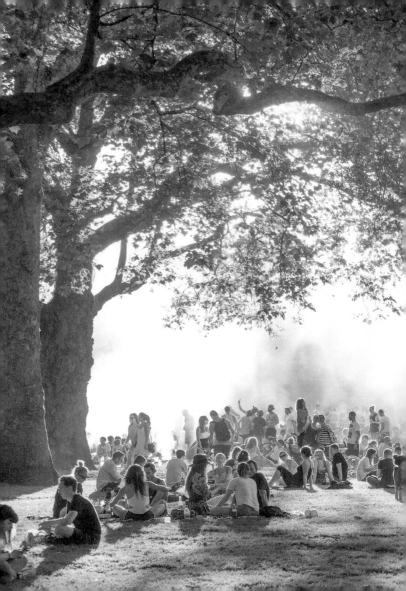

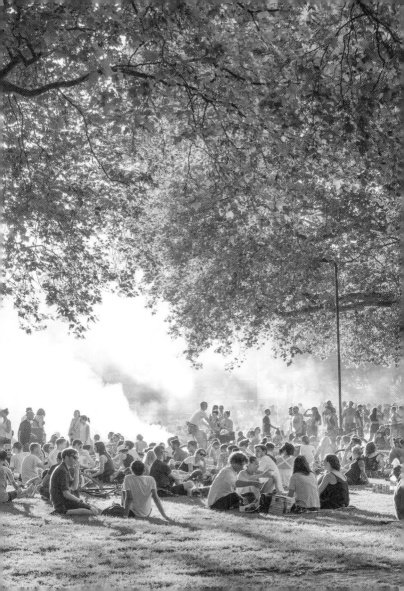

A PERFECT WEEKEND

Friday night

Start your weekend with a selection of succulent skewers at Jidori (no.2), before popping across the road to catch an experimental gig at Café Oto (no.62). Finish the night a tipple or three at Ruby's (no.66).

Saturday morning

Clear your head with a stroll around Victoria Park (no.33), then have breakfast at Pavilion (no.9) and a quick browse in Haus (no.37). Swing by Chisenhale Gallery (no.53) for an art fix, before walking along the canal to Broadway Market (no.32).

Saturday lunch

Stop for a coffee at Climpson & Sons (no.27) before navigating the food stalls and dropping in to see the latest arrivals in Artwords (no.44). Wend your way to Bistrotheque (no.12) for a leisurely late lunch and a bloody Mary.

Saturday afternoon

Walk to Shoreditch via the canal for a shopping spree, stopping off at Labour and Wait (no.39), Aida (no.46) and SCP (no.42). Then refuel with a coffee at Leila's Shop (no.8) or a snack at The Kitchens (no.10) in Old Spitalfields Market.

Saturday evening

Savour a well-earned glass of something at Sager + Wilde (no.60) or The Marksman (no.58) before dinner at Morito (no.16). Head to Moth Club (no.64) afterwards for dancing until late.

Sunday brunch

Wake up with a swim at London Fields Lido (no.35), coffee at nearby E5 Bakehouse (no.5) and a peek inside Bonds (no.38). Stop by Mare Street Market (no.13) for brunch before wandering down to see some friendly wildlife at Hackney City Farm (no.30).

Sunday afternoon

Soak up the floral delights of Columbia Road Flower Market (no.34) before strolling to Brick Lane. Visit the Beigel Shops (no.15) then meander down to Brick Lane Bookshop (no.47) and Libreria (no.45) and end up at the Whitechapel Gallery (no.50).

Sunday evening

Pop into The Spread Eagle (no.61) for a pint before catching an early screening at The Castle Cinema (no.65). Wander over to P. Franco (no.21) for small plates and wine to finish the weekend off in style.

HACKNEY: A BRIEF OVERVIEW

Shoreditch – crowds gravitate here for the ever-expanding selection of restaurants, bars, shops, hip hotels, street food stalls and nightlife. Fun and colourful but at times a little in-your-face.

Dalston – Centred around Kingsland High Street, this is the home of great late-night Turkish food, cheap Ridley Road Market groceries, basement dive bars and messy nights out.

London Fields – The eponymous green space and its surrounding streets attract dog walkers, lido swimmers, coffee lovers, hipster barbecuers and a Saturday surge of Broadway Market goers.

Victoria Park – Picturesque residential streets surround this vast green space, alongside which lies a quaint cluster of local shops, cafés and pubs known as Victoria Park Village.

Hackney Central – The heart of the borough. Busy Mare Street is lined with high-street shops, council buildings and pubs.

Hackney Wick – artists' studios, warehouses and the Olympic Stadium are found in this spacious former industrial area.

Clapton – Over the last few years this has become the latest Hackney hotspot, with a constant stream of exciting new bar, café and restaurant openings.

Stoke Newington – Families, creatives and trendy brunchers flock to Stoke Newington Church Street for its shops, cafés and green spaces.

Stamford Hill – with the largest Hasidic Jewish population in Europe, this quiet neighbourhood stretches up to Tottenham and houses the Stokey overspill.

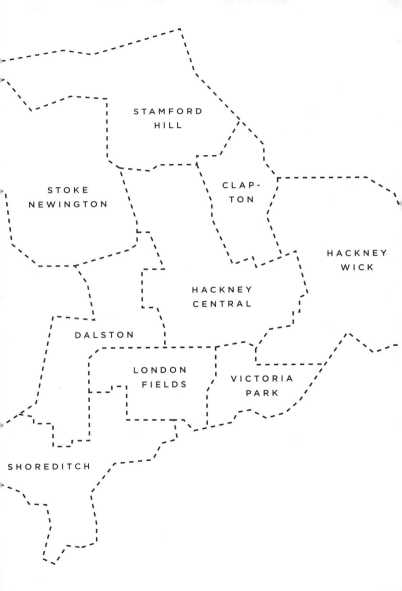

-1-

LEROY

Wine bar and restaurant

A leading light in a new generation of restaurants transforming Shoreditch from a stag-party mecca into a hunting ground for London's most discerning foodies. Although Leroy has excellent wine credentials (its owners are sommeliers), the Michelin-starred food is the main event – classy bar snacks (like the whipped cod's roe with crisps), cheese and charcuterie, and thoughtfully crafted plates of deliciousness.

18 Phipp Street, EC2A 4NU
leroyshoreditch.com

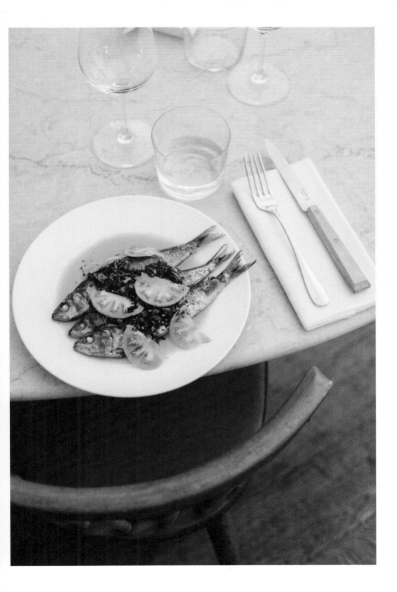

-2-

JIDORI

Modern Japanese restaurant

In Japan, you'll find plenty of izakayas – pub-like taverns with superior bar food to accompany saké-sinking sessions. Now there's one in Dalston too. The folks behind Jidori shipped a grill over from Tokyo to open this stylish but simple restaurant. The signature dish is yakitori: succulent grilled skewers of chicken (thigh, wing, breast, heart, liver – nothing goes to waste here) served with delicate sides, Asian-leaning cocktails and tasty small plates. The katsu curry scotch egg is a must.

89 Kingsland High Street, E8 2PB
jidori.co.uk

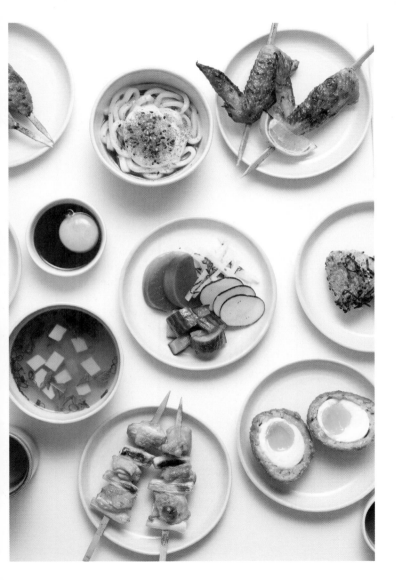

-3-

TEMPLE OF HACKNEY

Vegan fast food

Throughout the day, an enticing smell of fried food wafts along a queue of people waiting patiently for Temple of Hackney's hangover-busting treats. This place dishes up all the burgers, fried chicken, fries and mac 'n' cheese that you'd expect from a takeaway joint. The only difference here is that it's 100% vegan – although you'd barely notice thanks to its clever use of meat-free alternatives. It's guilt-free junk food heaven for vegans, and everyone else.

10 Morning Lane, E9 6NA
templeofseitan.co.uk

BURGER

con, cheese, lettuce, pickles,
o

£6

SPICY BURGER

eese, coleslaw, jalapeños,
and chipotle mayo

£6

HOT WINGS

4 wings in spicy buffalo sauce
with ranch mayo (GFO)

£5

TWIST WRAP

2 wings, lettuce tomato and
pepper mayo (GFO)

£5

2 PIECE

2 fillet pieces with your
choice of mayo

£5

TEMPLE JR
BURGER

2 wings with pepper mayo

£4

MAKE IT A
Meal

Add a regular fries
+ karma cola for £2

-4-

LITTLE DUCK /
THE PICKLERY

Fermenting kitchen and restaurant

Kimchi, kraut, kombucha – as the name suggests, the latest spot from the people behind Ducksoup and Rawduck is a haven of preserved, fermented and pickled delights. But it's much more than a room of fizzing jars. It's also a cosy all-day restaurant with a daily-changing menu quaintly scrawled on a blackboard, a vibrant selection of natural wines and 'drinking vinegars', and an open kitchen that will make you feel like you're eating at a (very talented) friend's house.

68 Dalston Lane, E8 3AH
littleduckpicklery.co.uk

-5-

E5 BAKEHOUSE

Bakery and coffee shop

This bakery and coffee shop on a quiet street by London Fields makes the best sourdough in East London, hands down. Alongside those incredible fresh loaves, E5 also dishes up delicious coffee (made in their sister branch, E5 Roasthouse) and a dangerously good selection of handmade cakes. Follow the sweet, yeasty smell into their airy railway arch, grab a seat at a communal table and order some slabs of buttered toast with all the spreads you could wish for.

Arch 395, Mentmore Terrace, E8 3PH
Other branch (E5 Roasthouse):
2 Cotall Street, E14 6TL
e5bakehouse.com

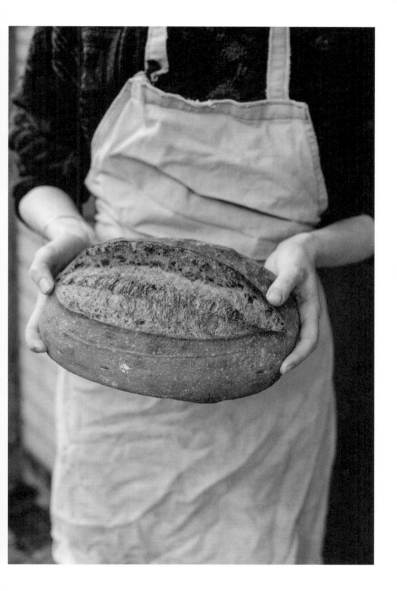

-6-

ROCHELLE CANTEEN

Modern British restaurant

Hidden away in a converted bike shed in an old Victorian school, Melanie Arnold and Margot Henderson have been quietly serving up simple and satisfying British fare to those in the know since opening in 2004. Rochelle Canteen still retains its eccentricities: dinner is only served Thursday to Saturday (although you can get breakfast and lunch every day), you must be buzzed in at the school gate and you have to be off the premises by 10pm sharp, so the end of your meal can feel a tad abrupt. But the quality more than matches the quirk.

16 Playground Gardens, E2 7FA
arnoldandhenderson.com

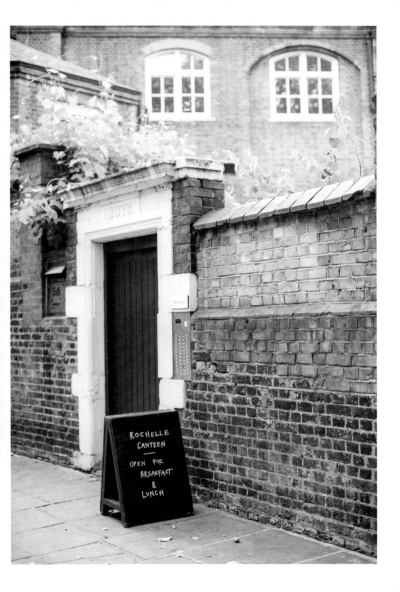

-7-

E. PELLICCI

Traditional café

Opened in 1900 and still run by the same family, this Grade-II listed art deco greasy spoon in Bethnal Green is an East End institution, cranking out first rate fry-ups, pie and mash, Italian specials, strong builder's tea and side orders of lively banter. At breakfast and lunchtime, the wood-panelled and Formica interior heaves with regulars reading well-thumbed newspapers and gossiping with staff. Share a table and join the buzz.

332 Bethnal Green Road, E2 0AG
epellicci.com

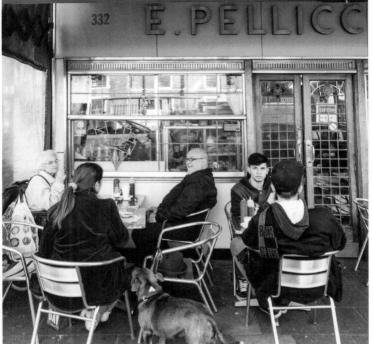

-8-

LEILA'S SHOP
Café and grocery

If Shoreditch is a village, Leila's is the local store and café. It has an honest approach to fresh, organic produce, much of which powers its seasonal menu of simple but completely mouth-watering brunches and lunches. Try the eggs with sage on a Sunday morning followed by some grocery shopping next door. Understated yet spectacular: it's a must.

15-17 Calvert Avenue, E2 7JP
twitter.com/leilas_shop

-9-

PAVILION

Lakeside café and bakeries

The one problem with this beloved café and bakery is that it's just too damn popular. But don't be put off by the queues: even at the height of summer there's plenty of space on the outdoor communal tables for brunching locals, families, dog walkers and morning-after Tinder dates. Their classic fry-ups are dished out all day, but if you want to try the divine Sri Lankan egg hoppers, turn up early before they sell out.

Lakeside café: Victoria Park, E9 7DE
Bakeries: 130 Columbia Road, E2 7RG
and 18 Broadway Market, E8 4QJ
instagram.com/pavilionbakery

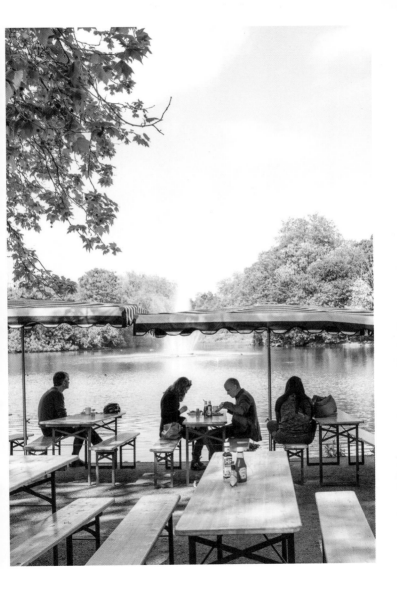

-10-

THE KITCHENS

Collection of street food stalls

In the centre of Old Spitalfields Market, chef Nuno Mendes has curated 10 impressive food stands kitted out with proper kitchens, a revolving roster of tasty residents and nearby benches to perch and gobble. Some are outposts of existing restaurants like Monty's Deli and Lahpet; others are popular street food stalls. The result is a culinary journey from salt beef sandwiches to katsu curry and beyond.

16 Horner Square, E1 6EW
oldspitalfieldsmarket.com

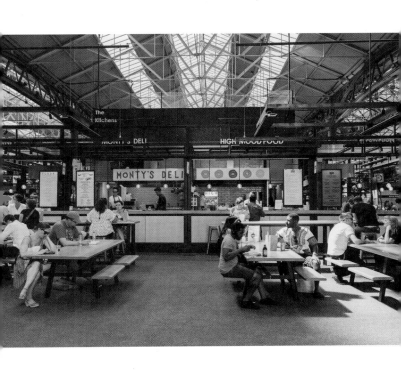

-11-

BÚNBÚNBÚN

Vietnamese restaurant

There's no shortage of vibrant Vietnamese food at the bottom of Kingsland Road – in fact, there were 14 restaurants on the 'Pho Mile' last time we counted – but BúnBúnBún is a welcome addition. They serve all the classics, but you should opt for their specialty, the Hanoi street food favourite Bun Cha: a big satisfying bowl of rice noodles, lemongrass-marinated pork, salad and fried spring rolls. Yum.

134B Kingsland Road, E2 8DY
bunbunbun.co

-12-

BISTROTHEQUE

Modern European restaurant

A pioneer of fashionable East London eateries, after 15 years this stylish restaurant is still as popular as ever. You'll feel like you've been let in on a secret as you ascend the quiet staircase off a Bethnal Green back street to the airy, white-walled dining room. They make a mean pre-dinner cocktail at the Manchichi Bar, but weekend brunch is great too – especially when there's a pianist to soundtrack your eggs Benedict.

23-27 Wadeson Street, E2 9DR
bistrotheque.com

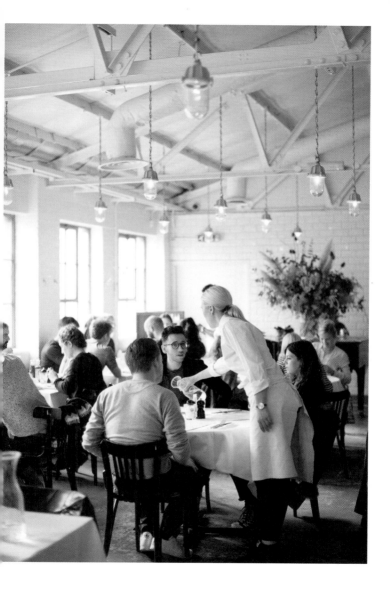

-13-

MARE STREET MARKET

Restaurant, bar and shops

If you want a good look at the new face of East London, there's nowhere better than this dining and shopping emporium. You'll find an independent record shop, well-stocked deli, florist and antiques dealer, as well as all-day dining, artisan coffee, sourdough pizzas, a large central bar and a radio station – all under one stylish roof. By day, the long benches are a sea of MacBook-tapping freelancers, but when 6pm hits, the lights go down and the craft beer starts flowing. It could be insufferable, but it's actually rather good.

117 Mare Street, E8 4RU
marestreetmarket.com

-14-

THE DUSTY KNUCKLE

Bakery and café

Tucked away down an alley in Dalston, The Dusty Knuckle started as a makeshift bakery in a shipping container with a mission to engage vulnerable young people through the power of bread-making. Four years on, they've opened a bigger café space next door which continues to provide valuable youth training and employment whilst serving up the freshest sandwiches, salads, cakes and pastries around.

Abbot Street Car Park, E8 3DP
thedustyknuckle.com

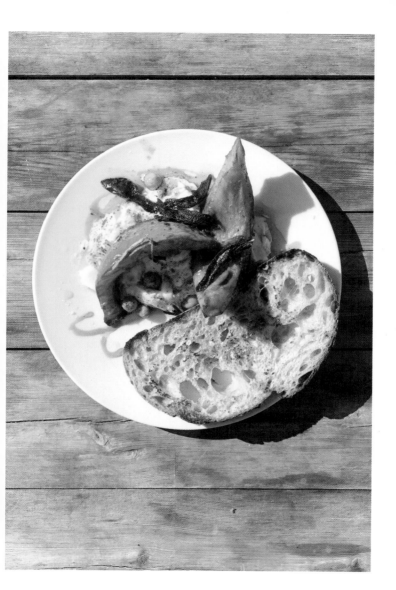

-15-

BRICK LANE BEIGEL SHOPS

Bakeries

If there's one thing that divides East Londoners, it's which of the two 24-hour Brick Lane beigel shops is best. 'The yellow one' and 'the white one' are both masters of their trade, cramming freshly baked beigels with juicy salt beef and mustard or smoked salmon and cream cheese, but the queue in the white-fronted Beigel Bake is always longer, plus they have a winning edge: fresh black rye bread on Thursdays and Saturdays only.

155 Brick Lane and 159 Brick Lane, E1 6SB

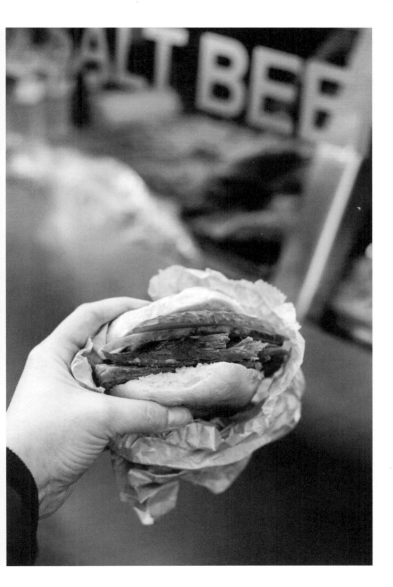

-16-

MORITO

Tapas and mezze restaurant

First there was world-famous Moro in Exmouth Market, then its tiny spin-off Morito next door. Thankfully, the third incarnation came to Hackney, this time with space to fully appreciate its Spanish, North African and Mediterranean deliciousness. Sit at the grand marble horseshoe bar, order a bit of everything (especially the fried aubergine with pomegranate molasses and feta) and experience pure happiness.

195 Hackney Road, E2 8JL
moritohackneyroad.co.uk

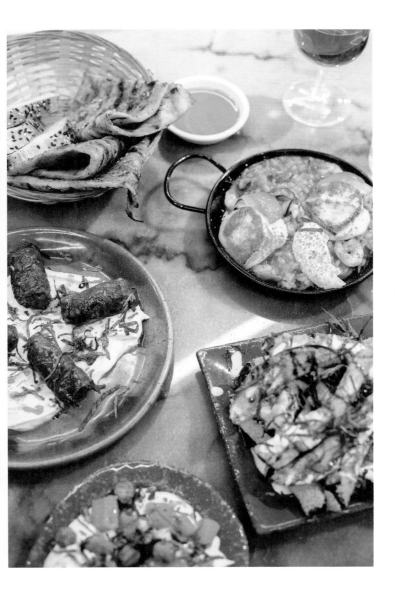

-17-

THE GOOD EGG

Café and restaurant

Church Street is a bruncher's paradise, but nothing quite hits the spot like The Good Egg. Each weekend, hopefuls line up for its ingeniously innovative and creatively executed Israeli-infused nosh. There are eggs aplenty, true, but the menus go far beyond that with delicious collisions, such as bacon and marbled egg pita with date jam, alongside homemade pickles and house-smoked meats. Book for dinner to sidestep the crowds.

93 Stoke Newington Church Street, N16 0AS
thegoodeggn16.com

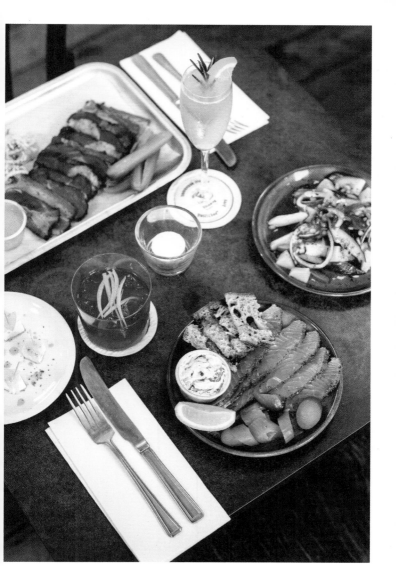

-18-

CRATE BREWERY
Bar and pizzeria

Summer nights were made to be spent at this canalside temple to craft beer – eating stone-baked pizza, watching narrowboats glide by, while sucking on a bottle of hoppy home-brewed ale. Unfortunately, almost everyone else in Hackney Wick feels the same; it can get impossibly busy on a warm evening. The good news is that its ever-changing selection of freshly brewed beers and crispy-based pizzas taste great all year round, whatever the weather.

The White Building, Queen's Yard, E9 5EN
cratebrewery.com

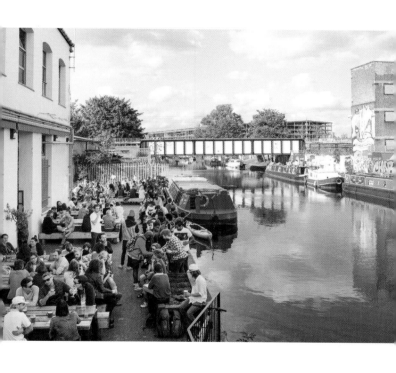

-19-

CORNERSTONE

Modern British seafood

Hackney Wick has never been a dining destination, but that could all be about to change with the arrival of Cornish chef Tom Brown's lauded seafood restaurant. The industrial-chic dining room is the place for knock-out fish-based delights: pickled oysters, potted shrimp crumpets, cheesy smoked haddock tart, mackerel pâté – even the toasted sourdough is spectacular. Put your trust in Tom and splash out on the chef's selection – you won't be disappointed.

3 Prince Edward Road, E9 5LX
cornerstonehackney.com

-20-

UCHI

Japanese restaurant

You'd never expect to find this Japanese culinary spot hidden on a residential backstreet in Clapton. Even so, a free table at Uchi is a precious thing. Everything about this restaurant is satisfying, from the handsome crockery and careful presentation to the rotating board of specials – fingers crossed it features the black rice veg tempura roll on your visit.

144 Clarence Road, E5 8DY
uchihackney.com

-21-

P. FRANCO

Wine shop, bar and restaurant

Discreetly situated under the 'Great Wall' cash-and-carry sign, over the last few years this Lower Clapton wine shop has grown into a cult foodie destination. It's owned by the folk behind Broadway Market's natural wine haven Noble Fine Liquor, so the booze is brilliant, of course. More unexpectedly, so is their food: uncomplicated, seasonal cooking conjured up on two induction hobs by a range of impressive guest chefs. Turn up, squeeze in and enjoy.

107 Lower Clapton Road, E5 0NP
pfranco.co.uk

-22-

SMOKING GOAT

Thai bar and restaurant

Inspired by late-night food stalls in Bangkok, Smoking Goat is an all-sensory experience: the air buzzes with chatter, chaos and cooking clatter, and although there's often a hefty wait for tables (leave your name and come back), as soon as you take your first bite, all will be forgiven. Order the chilli fish sauce wings, punchy economy curry, lardo fried rice (vegetarians, it's worth straying for) and as many other dishes as you can fit on your table. Prepare to sweat, shout and leave totally sated.

64 Shoreditch High Street, E1 6JJ
smokinggoatbar.com

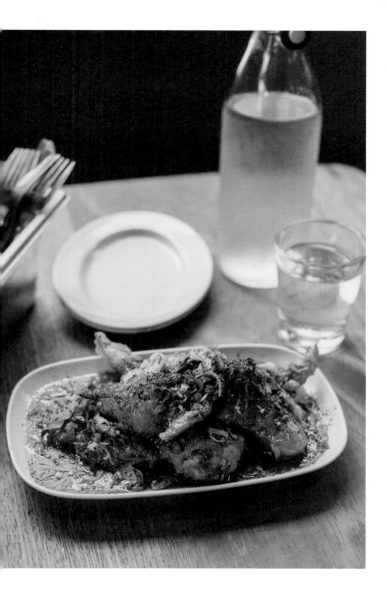

-23-

THE NED

Hotel, restaurants and bar

Nothing prepares you for how lavish The Ned is. The former, rather austere, Midland Bank is now an impossibly grand five-star hotel with soaring ceilings, overstuffed upholstery, polished wood and glistening marble as far as the eye can see. As well as the 250 bedrooms, there are 10 restaurants serving everything from sushi to spaghetti, a spa, two pools and the vault bar where you can deplete your funds on cocktails surrounded by 3,000 original safety deposit boxes (all empty, unfortunately).

27 Poultry, EC2R 8AJ
thened.com

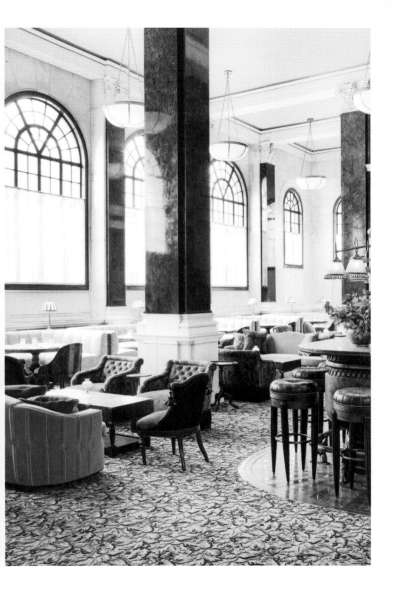

-24-

ACE

Hotel and restaurant

This ridiculously hip boutique hotel has everything you need for the full Shoreditch experience (though you'll have to bring your own facial hair). A workspace by day overflowing with laptops and flat-tops, at night Ace's lobby transforms into a lively late-night bar full of creative types passing between the Hoi Polloi restaurant, basement club Miranda and the glass roof terrace. Each of the rooms is kitted out with covetable mid-century furniture and (of course) a turntable with record selection.

100 Shoreditch High Street, E1 6JQ
acehotel.com/london

-25-

TOWN HALL HOTEL

Hotel and restaurant

Back when Bethnal Green council had money to burn, it splurged on a town hall in high Edwardian baroque style. A century on, its green and white marble, lustrous teak, ornamental plasterwork and art deco furnishings were rescued from disrepair in its resurrection as a sumptuous luxury hotel. With suites larger and better equipped than a suburban family home, and rooms that wittily blend retro and up-to-the-minute contemporary design, you won't want to set a foot outside.

8 Patriot Square, E2 9NF
townhallhotel.com

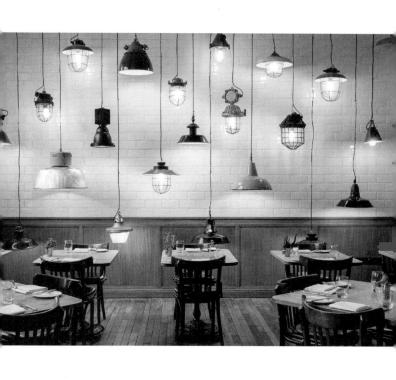

-26-

ALLPRESS

Coffee shop and roastery

It's a tough contest, but this coffee shop and roastery from Down Under serves some of the best espressos in East London. In their E8 location you can watch a batch of beans completing their roasting cycle while you taste the finished product in the café area. The sandwiches are deceptively filling, while wooden seats and a lack of wifi keeps the laptops away – more room for caffeine purists. Bag a spot in the front garden and you'll almost forget you're on a Dalston thoroughfare.

55 Dalston Lane, E8 2NG and
58 Redchurch Street, E2 7DP
uk.allpressespresso.com

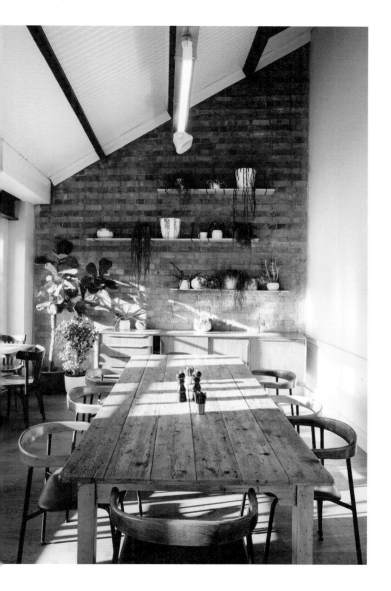

-27-

CLIMPSON & SONS

Coffee shop and roastery

One of the original pioneers of the city's specialty coffee scene, Climpson has been waking up East Londoners since 2002. The competition for a coveted spot on the benches outside is fierce, and at busy times the queue for a brew snakes down Broadway Market. On Saturdays, when the market is on, you can also pick up a quick fix at Climpson's coffee cart a hundred metres down the road near the canal.

67 Broadway Market, E8 4PH
Coffee carts: Broadway Market, E8 4QJ
and Old Spitalfields Market, E1 6EW
climpsonandsons.com

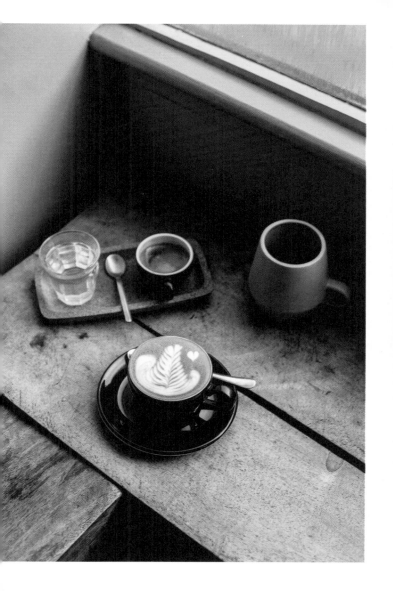

-28-

OZONE

Coffee shop and roastery

Of course this Kiwi-owned roastery makes an excellent cup of Joe: they roast their own beans and serve it impeccably via Aeropress, v60 and all the other ways the cool kids brew these days. But unlike some of their caffeine-slinging rivals, the food at Ozone is just as much of a draw. The brunch menu is so much more than your usual breakfast fare (get the cornbread with fermented chilli butter), and yes, it's worth queuing for.

11 Leonard Street, EC2A 4AQ
ozonecoffee.co.uk

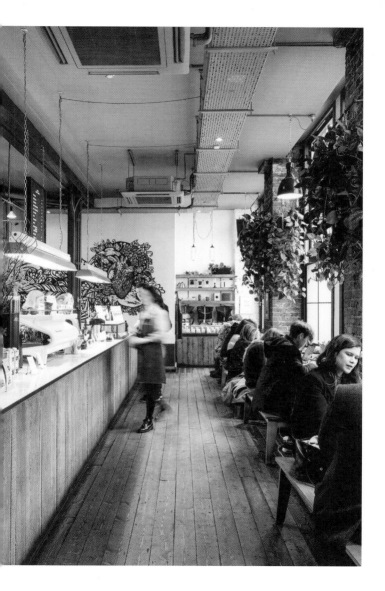

-29-

NUDE ESPRESSO

Coffee shop and roastery

Hanbury Street has not one but two manifestations of this coffee haven. The flagship café at number 26 is just right for a leisurely latte and all-day brunches, while the dedicated roastery opposite is a magnet for coffee geeks. From Thursday to Saturday you can stock up on Nude's full complement of beans, savour the flavours in-house and nibble on freshly baked banana bread.

25 and 26 Hanbury Street, E1 6QR
Other branches: 8 Bell Lane, E1 7LA
and 4 Market Street, E1 6DT
nudeespresso.com

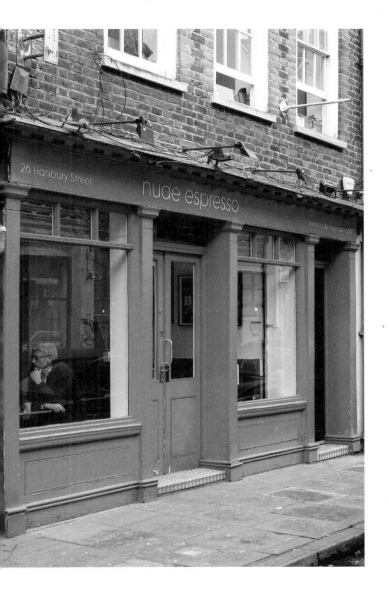

-30-

HACKNEY CITY FARM

Farm and café

East London is full of wild animals (just venture into Shoreditch on a Saturday night) but you'll find some of the better behaved varieties at Hackney City Farm. On arrival you'll be greeted by a rabble of free-range chickens and ducks, then there are the resident goats, sheep, rabbits, donkeys and gargantuan pigs to meet and greet. A strangely calming, pastoral experience in the heart of the city. Once you're animal-ed out, head in for a rustic brunch at Frizzante café.

1a Goldsmiths Row, E2 8QA
hackneycityfarm.co.uk

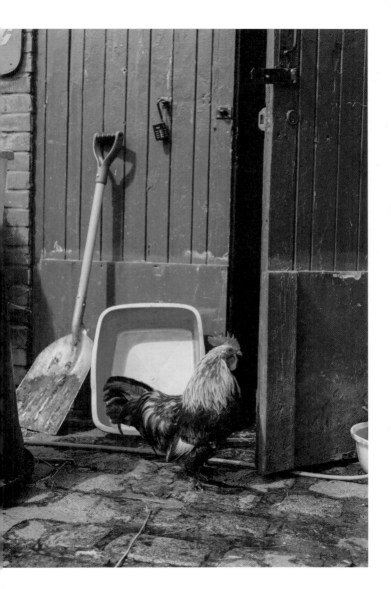

-31-

TOWER HAMLETS CEMETERY PARK

Nature reserve

A walk through a disused nineteenth-century graveyard might not sound that appealing but a trip to Mile End's 33-acre park is always surprisingly uplifting. Amongst the picturesque crumbling gravestones, there's a wealth of wild flowers, plants, birds and butterflies to be discovered. Take a peaceful stroll through the woodland, join one of the free guided tours (third Sunday of the month, 2-4pm) or pop in for one of the other events hosted there throughout the year.

Southern Grove, E3 4PX
fothcp.org

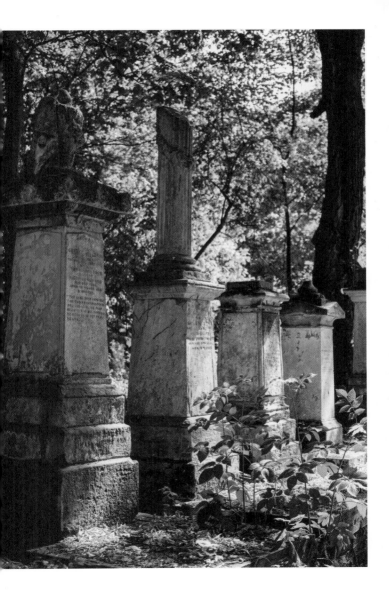

-32-

BROADWAY MARKET

Saturday market

Stretching down from London Fields to Regent's Canal, Broadway Market is the place to pick up the best that East London has to offer. Fashionable, hungry and mostly hung-over Londoners make the pilgrimage every Saturday to savour the street food and to browse the handmade goodies ranging from unusual cheeses to haggis toasties to baby clothes. Get there early to beat the crowds, secure a seat outside a café and indulge in some serious people-watching.

Broadway Market, E8 4QJ, Saturday 9am-5pm
broadwaymarket.co.uk

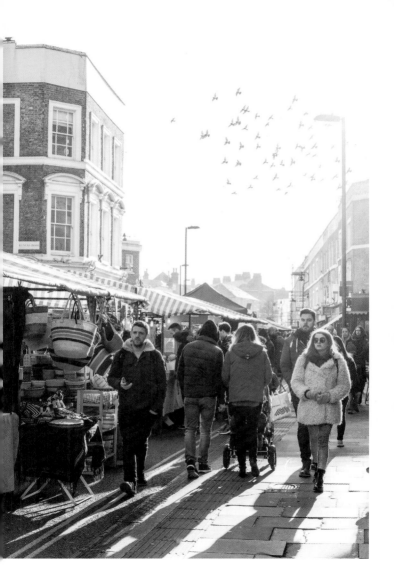

-33-

VICTORIA PARK

Park

Serving East Enders since 1845, the 86-hectare Vicky Park is the emerald in East London's crown and a park for all seasons. Wrap up for an autumn stroll along the canal, take a weekend meander around the boating lake and pagoda (stopping off at the Pavilion Café for breakfast [no.9], or street food at their Sunday market), gawp at the annual Guy Fawkes extravaganza or head to one of the music festivals that take over the park's east side each summer.

Grove Road, E3 5TB
Food market: Sunday 10am-4pm

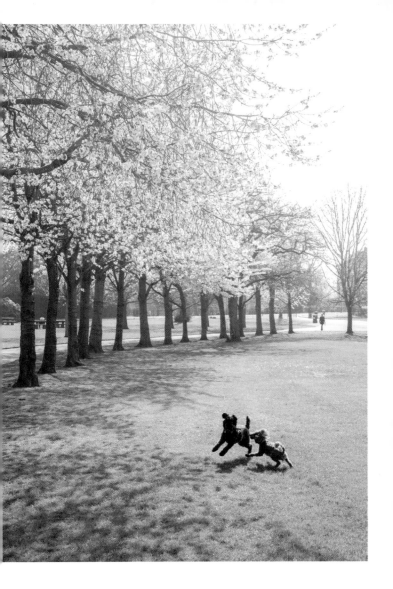

-34-

COLUMBIA ROAD

Sunday flower market

Every Sunday, this sleepy Victorian street is transformed into a frenzy of fragrant flowers and foliage. Locals arrive ridiculously early to stock up on seasonal blooms, houseplants and bulbs, and banter with stallholders before the tourists descend around noon, when it becomes too busy to move. But what's the hurry? Wait until packing-up time around 3pm and you'll come away with armfuls of flowers at bargain prices.

Columbia Road, E2 7RG, Sunday 8am-3pm
columbiaroad.info

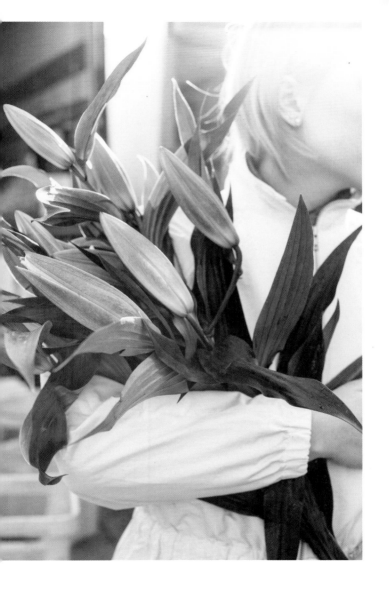

-35-

LONDON FIELDS LIDO

Outdoor swimming pool

There's no better place for a dip in East London than London Fields Lido. The Olympic-sized heated pool is open all year round, with sweaty, impatient queues across the park in summer and hardcore shivering swimmers dashing in during the colder months. It's always popular for pre-work swims, but those in the know dive in on a weekend evening when the pool is open until 9pm and practically empty.

London Fields West Side, E8 3EU

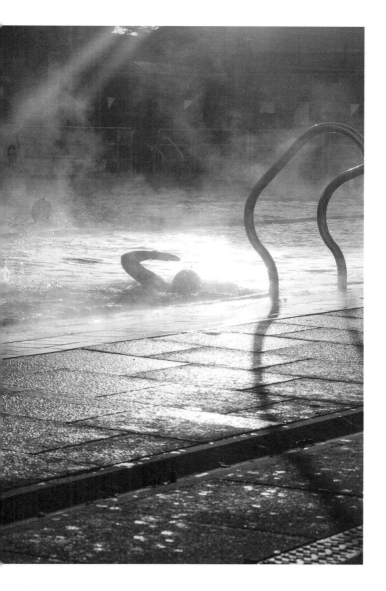

-36-

DALSTON EASTERN CURVE GARDEN

Café and garden

You could easily miss this wonderful community garden hidden opposite Dalston Junction station. A scrap of the old Eastern Curve railway line has been transformed, offering shady sitting-spots amongst trees and flowers, wildlife-friendly planting, and raised beds where locals can nurture herbs and vegetables. At the garden pavilion there's a bar, a pizza oven, sofas and blankets for winter, while in the summer they stay open late for drinks, acoustic gigs and lantern-lit parties.

13 Dalston Lane, E8 3DF
dalstongarden.org

-37-

HAUS

Furniture and homeware

The aesthetically-astute couple (he's a furniture designer, she's a sculptor) behind this small contemporary homeware store in Victoria Park Village have done all the hard work for you when it comes to updating your interiors. Their considered selection of furniture, homeware and lighting from both big names and independent makers is artfully displayed in the cosy corner shop, making it a pleasure to browse, and dangerously easy to make a rather pricey impulse purchase.

39 Morpeth Road, E9 7LD
hauslondon.com

-38-

BONDS

Homeware and coffee shop

Not content with perfuming our homes, candle makers Earl of East have opened two beautifully curated lifestyle stores: one in Coal Drops Yard, King's Cross, and this original, smaller studio in London Fields. Handcrafted products made by local brands line their shelves and there's often a pop-up showcasing a particular maker. Drop in for an Allpress coffee, peruse the latest goods, and perhaps sign up for one of their crafty courses such as spoon carving, terrarium workshops or candle making.

5a Gransden Avenue, E8 3QA and
Coal Drops Yard, Stable Street, N1C 4AB
bondshackney.co.uk

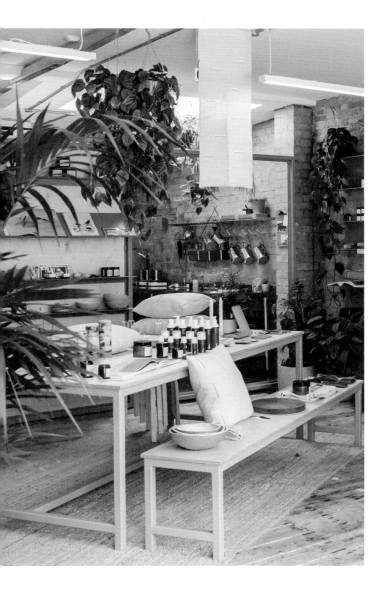

-39-

LABOUR AND WAIT

Homeware

Ration-book chic is the order of the day at this unashamedly nostalgic homeware store. You'll find you never knew you needed a brass pen until it calls to you from among the speckled enamel baking trays, beeswax candles, wooden gardening tools, canvas fisherman's smocks and straw brooms. If beauty can be found even in life's most mundane objects, this place has surely found it.

85 Redchurch Street, E2 7DJ
labourandwait.co.uk

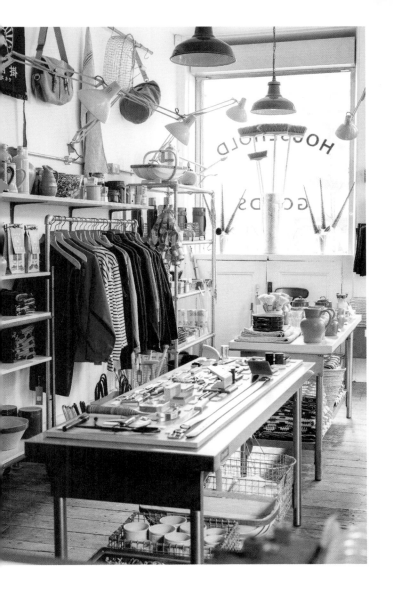

-40-

BURLEY FISHER BOOKS

Bookshop and café

Haggerston residents are fiercely proud of their feisty, local independent bookshop. Owners Jason Burley and Sam Fisher stock a thought-provoking selection of politics, philosophy, art and fiction titles, pamphlets and fanzines, and also host an eclectic series of book launches, readings and literary salons to bring the words to life. After browsing, head to the chilled little café at the back of the store where you can lose yourself in a new book over a coffee and a bagel.

400 Kingsland Road, E8 4AA
burleyfisherbooks.com

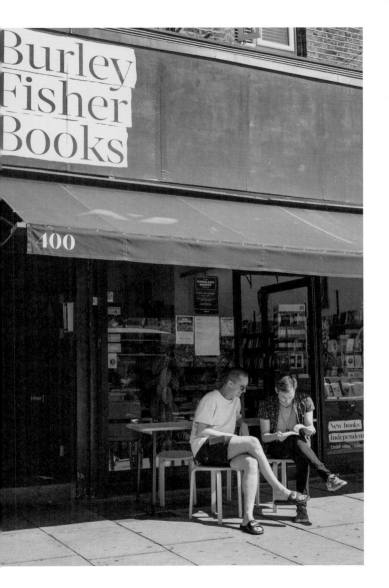

-41-

PAM PAM

Women's trainers and fashion

There's more to this cute concept store than first meets the eye. As you'd expect from the women's trainer experts, there's an impressive array of sought-after footwear, but venture past these shelves and you'll discover two rooms of jewellery, ceramics, skincare and accessories, plus a carefully curated edit of streetwear and sportswear – an ideal pairing to your box-fresh sneakers.

129 Bethnal Green Road, E2 7DG
pampamlondon.com

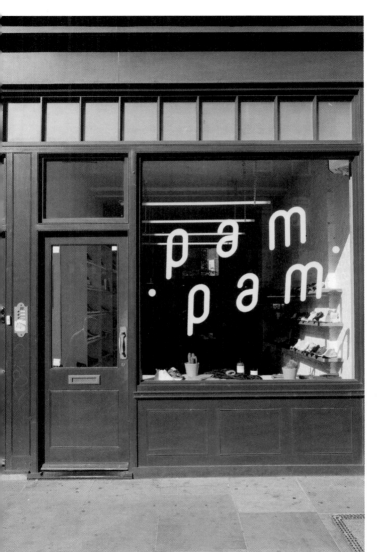

-42-

SCP EAST

Design, furniture and homeware

A three-floor design mecca full of intensely desirable things to kit out every room, Sheridan Coakley's seminal flagship store has been furnishing the homes of design-hungry East Londoners since the gentrification stone age (1985, to be exact). Future design stars share space with established names, and you can pick up anything from affordable kitchen accoutrements to eye-wateringly expensive 'investment' furniture. Sip on a piccolo at the in-house coffee shop while you contemplate splashing some cash.

135-139 Curtain Road, EC2A 3BX
scp.co.uk

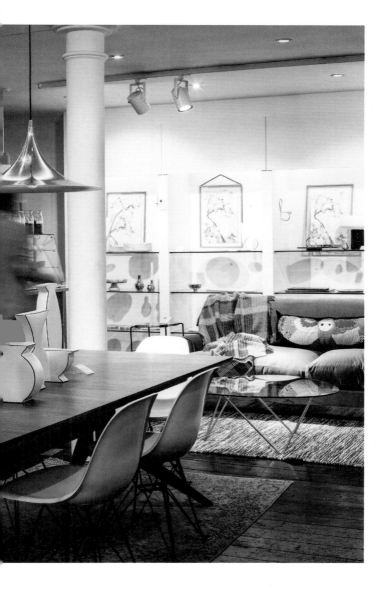

-43-

CONSERVATORY ARCHIVES

Plant shop

If Kew Gardens is just too far away, then enjoy (and buy) the meticulously chosen houseplants at this Hackney hothouse which will fulfil all your botanical desires. The former ironmongery is stuffed floor-to-ceiling with a luscious, immaculately presented forest of succulents and horticultural exotica with which to lavishly decorate your home or work. Allow plenty of time to browse the chunky palms, delicate hanging plants and angry-looking cacti.

493-495 Hackney Road, E2 9ED
conservatoryarchives.co.uk

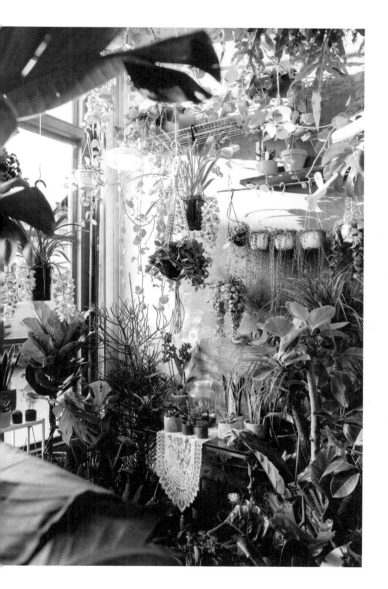

-44-

ARTWORDS

Bookshop

Your coffee table never needs to look underdressed again, thanks to this pair of impressive art bookshops that offer so much more than the usual run of gorgeous tomes on contemporary art. You'll find rare imports and a hefty selection of hard-to-come-by magazines from across the world, covering topics ranging from architecture to advertising. It makes for wonderful browsing, and the staff really know their stuff.

69 Rivington Street, EC2A 3AY
and 20-22 Broadway Market, E8 4QJ
artwords.co.uk

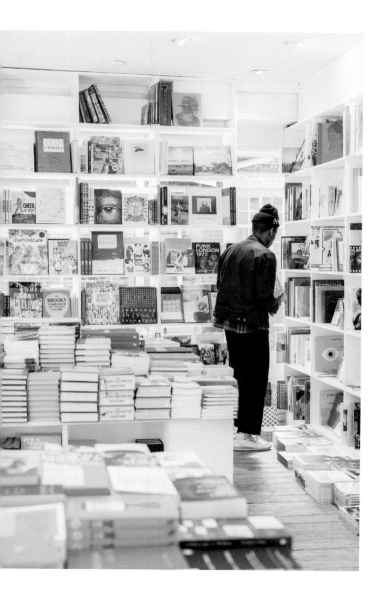

-45-

LIBRERIA

Bookshop

With no coffee or wifi, just endless shelves of gorgeous books, Libreria bills itself as a refuge from the digital (at last, an escape!). Just off Brick Lane, it will reignite your love for the physical book with its beautiful special editions, fanzines, art publications, risograph printing workshops and poetry readings. It's open late from Thursday to Saturday, giving you plenty of time to curl up and read in one of the cosy cubbyholes built right into the shelves.

65 Hanbury Street, E1 5JP
libreria.io

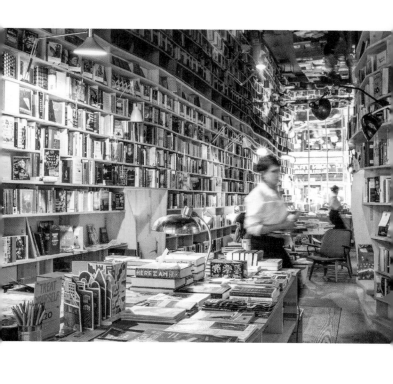

-46-

AIDA

Fashion and homeware

Everything at this airy post-industrial concept store has been painstakingly considered, from the idiosyncratic styling by independent European designers to the retro grooming supplies (non-ironic, honest), through to the locally-sourced homeware, hand-picked book selection and vintage hairstyling parlour. There's even a tranquil little café serving cold-pressed juices and brightly coloured lattes.

133 Shoreditch High Street, E1 6JE
aidashoreditch.co.uk

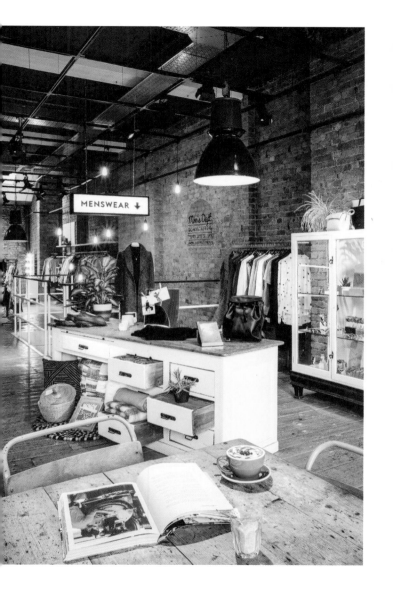

-47-

BRICK LANE BOOKSHOP

Bookshop

This little bookshop is a love song to East London and an essential pit stop for anyone ambling up Brick Lane. Historical gems and Ordnance Survey maps share the shelves with London photography books, work by local artists, guides to East End coffee shops, hidden walks and street art (it is Brick Lane after all).

166 Brick Lane, E1 6RU
bricklanebookshop.org

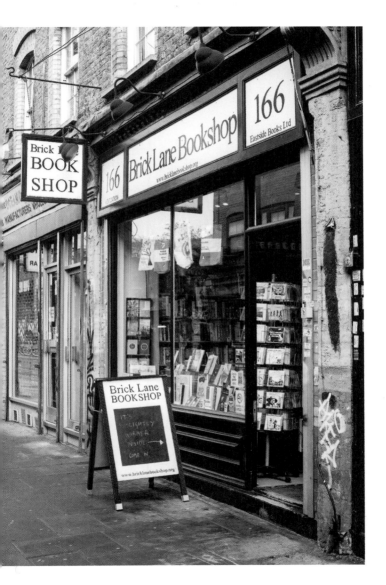

-48-

TRIANGLE

Homeware and fashion

Three friends set up this independent design store because of their shared love of beautiful things – clothes, jewellery, homeware, toiletries, furniture, and plenty of other stuff that's guaranteed to look elegant in your home. It's a celebration of good, simple design and a one-stop shop for all your Scandinavian minimalist and Japanese monochrome design needs.

81 Chatsworth Road, E5 0LH
trianglestore.co.uk

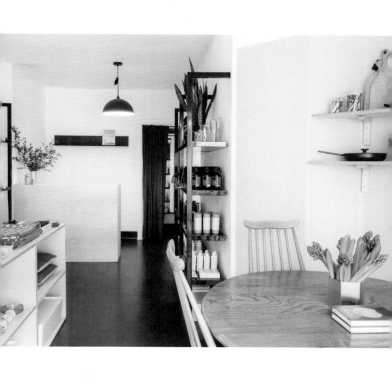

-49-

TURNING EARTH

Ceramic studio

It can feel like an epic journey navigating the Lee Valley industrial estates to find this pottery paradise, but once you do, you'll know why so many ceramic fans make the pilgrimage. The airy studio is full of hanging plants and potters calmly creating. Take a course to see what all the fuss is about or become a member to use the space. Be sure to pop into the nearby Lighthaus café for sustenance before making the trip home. They also have a smaller studio under the arches in Hoxton.

Top floor, 11 Argall Avenue, E10 7QE and
Railway Arches, 361-362 Whiston Road, E2 8BW
e2.turningearth.uk

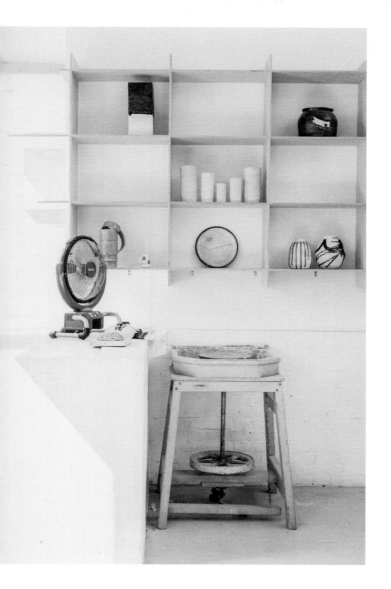

-50-

WHITECHAPEL GALLERY

Gallery

Founded in 1901, this cherished public gallery surpassed its mission to 'bring great art to the people of East London' long ago, scooping a jaw-dropping series of debut shows for some of art's biggest names – Pollock, Hockney, Rothko, Kahlo, Freud, and locals Gilbert & George among them. Leave time to forage the shelves of its bookshop (an outpost of Koenig Books) and fortify yourself at the wholesome Whitechapel Refectory or the After Hours bar.

77-82 Whitechapel High Street, E1 7QX
whitechapelgallery.org

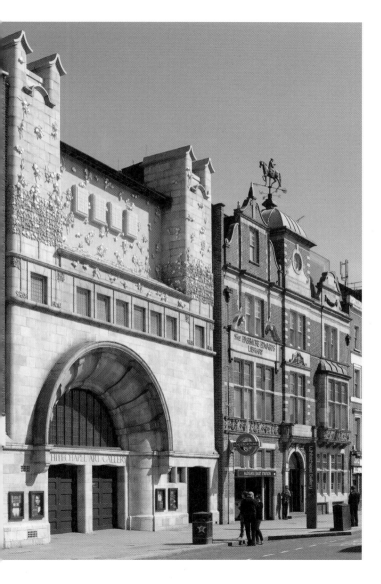

-51-

TRINITY BUOY WHARF

Lighthouse and arts venue

East London is home to London's only lighthouse, part of Docklands arts hub Trinity Buoy Wharf (where you'll also find a miniscule Michael Faraday museum, colourful containers full of studios and an incongruous American diner). No longer in use, today the lighthouse houses Longplayer, a continuous 1000-year-long piece of music recorded using Tibetan singing bowls. Listening to it echo around the former lamp room while overlooking the river is a magical experience – and just a short DLR ride away.

64 Orchard Place, E14 0JY
trinitybuoywharf.com

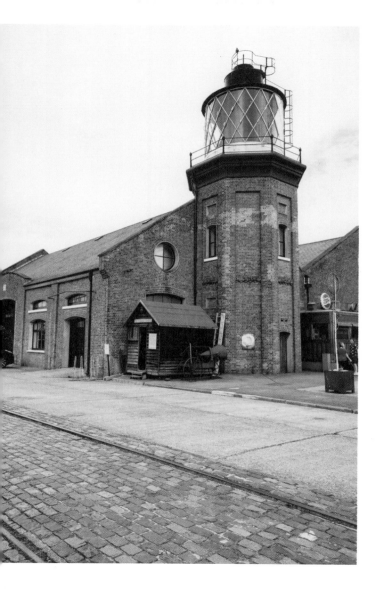

-52-

DENNIS SEVERS' HOUSE

Museum

Stepping into this atmospheric Georgian residence is like walking onto the set for a painting by an Old Master. That's exactly the effect eccentric American Severs was after, when he turned the rooms into 10 intimate scenes in the life of a fictional family of Huguenot silk-weavers, making them uncannily as if they'd only just walked out. Take a candlelit tour and be prepared to time-travel.

18 Folgate Street, E1 6BX
dennissevershouse.co.uk

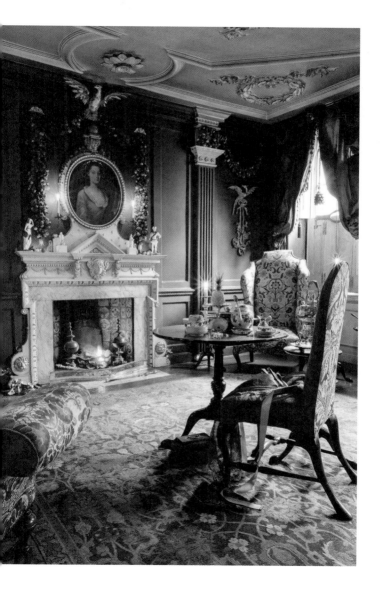

-53-

CHISENHALE GALLERY

Gallery

In a former industrial building on Regent's Canal, this trendsetting exhibition space is the gallery to see new work by future art stars and to find out what's happening right now in the contemporary art world. Shows cross all mediums including film, painting and sculpture, and there's an exciting programme of on- and off-site events and talks, including performances in Victoria Park.

64 Chisenhale Road, E3 5QZ
chisenhale.org.uk

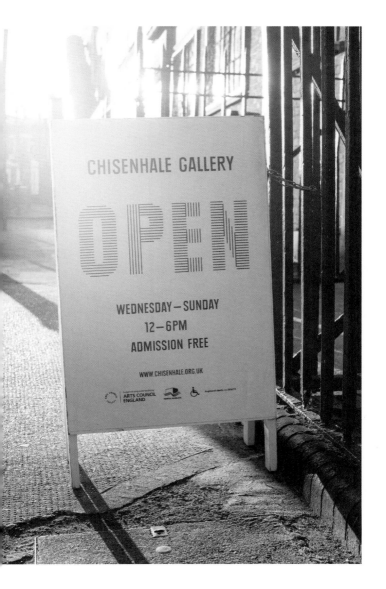

-54-

MAUREEN PALEY

Gallery

Beehive-haired art pioneer Maureen Paley moved to this Bethnal Green backstreet in 1999, making this a pioneering commercial gallery in the East End. Since then a cluster of other spaces have moved in around her, but this original still cuts above the rest for its consistently innovative unveiling of fresh talent alongside 'old' masters, including the likes of Wolfgang Tillmans and Gillian Wearing.

21 Herald Street, E2 6JT
maureenpaley.com

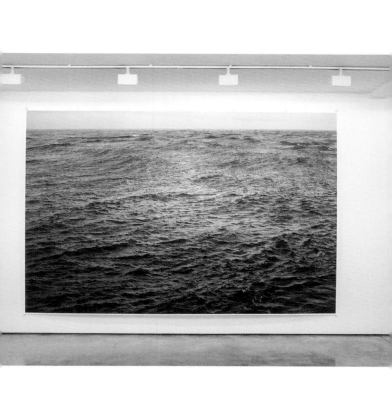

-55-

THE CLOWNS' GALLERY-MUSEUM

Museum

Dalston has a playful secret – it's the home of London's only museum dedicated to the art of clowning. Enter the small door behind Holy Trinity Church on the first Friday of every month (or by appointment) to discover the colourful collection of paintings, photographs, costumes, props and the enchanting 'clown egg register': a collection of hand-painted ceramic eggs documenting the unique look of each joker since the time of Joseph Grimaldi.

Cumberland Close, E8 3TF
clownsgallery.co.uk

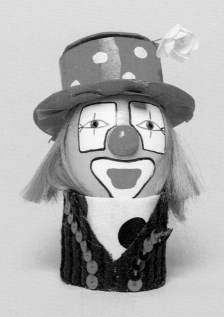

-56-

WILLIAM MORRIS GALLERY

Museum

Forget Brian Harvey from East 17; the baddest boy to come out of Walthamstow was surely renegade interior designer and craftsman, William Morris. A tour around his lavish teenage home is to be steeped in his life and work, not to mention his socialist campaigning, and will surely leave you inspired to do some major home redecoration. Leave time for tea in the café and a stroll around the adjoining Lloyd Park, where the young Morris pretended to fight dragons.

Lloyd Park, 531 Forest Road, E17 4PP
wmgallery.org.uk

-57-

MIRTH, MARVEL AND MAUD

Bar and venue

Walthamstow pleasure-seekers have been flocking to this Grade-II listed picture palace for more than 100 years. The former Granada Cinema hosted The Beatles, Johnny Cash, The Rolling Stones and Buddy Holly, and it remains a lively hub of culture and merriment: the ticket booth in the 1930s lobby is now a cocktail bar, there are comedy and film screenings in the basement and the main auditorium is being transformed into a 1,000-seat theatre.

186 Hoe Street, E17 4QH
mirthmarvelandmaud.com

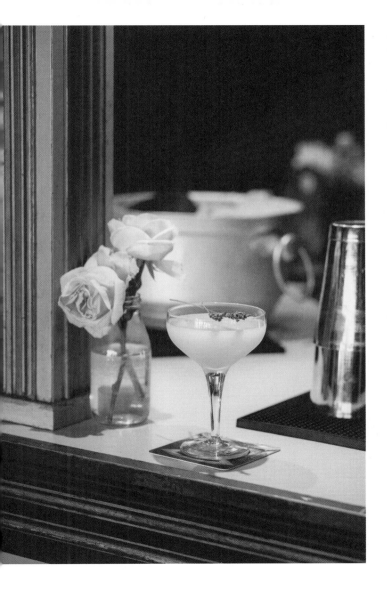

-58-

THE MARKSMAN

Pub and restaurant

The Marksman has been notching up awards since its reopening in 2015. The secret of its success is the way it marries top-drawer Michelin-lauded grub with the traditional character of your local wood-panelled boozer. Real ale aficionados, wine buffs and high-flying gastronauts mingle seamlessly, whether nestled on bar stools and leather banquettes downstairs, or chowing down in the fresh and contemporary dining room upstairs.

254 Hackney Road, E2 7SJ
marksmanpublichouse.com

-59-

GENESIS
Cinema

Anyone living in Whitechapel or Stepney is lucky to have the five-screen Genesis as their local independent cinema. It's the perfect place to catch new films on the big screen, showing major releases in a laid-back, arty setting as well as hosting poetry nights, gigs and festivals. You'd be hard pressed to find cheaper cinema tickets anywhere in East London. And where else can you watch a flick with snacks from the local 100-year-old bakery, Rinkoff?

93-95 Mile End Road, E1 4UJ
genesiscinema.co.uk

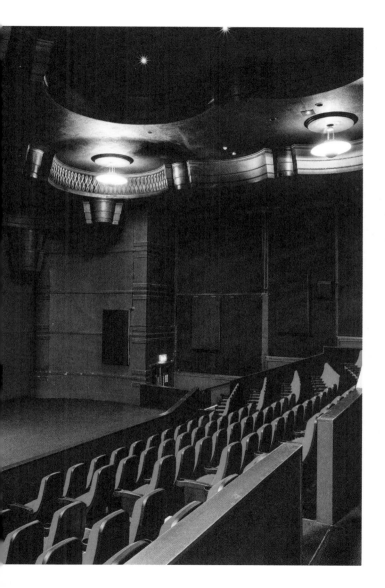

-60-

SAGER + WILDE

Wine bar

East End date night? This sleek corner bar is the place. The steamy windows and jazz soundtrack make for a relaxed, romantic setting, while staff are on hand to guide you as you delve into the small but dynamic wine list. Line your stomach with a few tasty bar snacks including the legendary jalapeño and cheddar cheese toastie – the ideal accompaniment to… well, pretty much anything.

193 Hackney Road, E2 8JL and
Arch 250, Paradise Row, E2 9LE
sagerandwilde.com

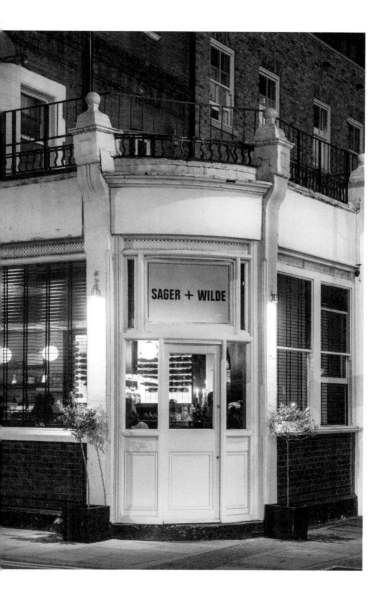

-61-

THE SPREAD EAGLE

Vegan pub

Recently restored to its original name, this handsome eighteenth-century corner pub on Homerton High Street is full of surprises. Not only does it have a shrine to Prince and a secret garden, it's also London's first totally vegan pub. Not just the food (by plant-based pioneers Club Mexicana), but also the drinks, decor and fittings are 100% animal-free. Perfect for a chilled mid-week taco and tipple or a spot of dancing on Friday and Saturday nights when they have DJs until 2am.

224 Homerton High Street, E9 6AS
thespreadeaglelondon.co.uk

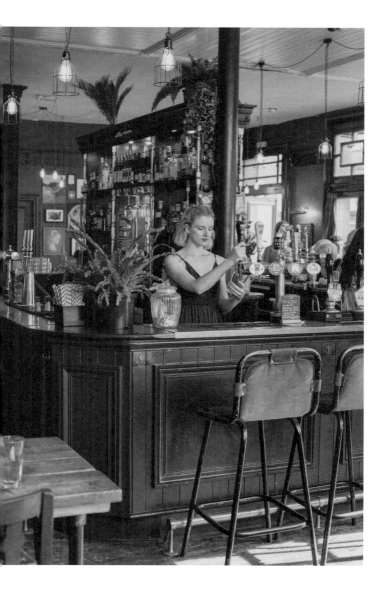

-62-

CAFÉ OTO

Music venue

You can rock up at this experimental music and arts venue night or day and there'll always be something to tickle your ears or taste buds. A great café and work spot by day, at night there's a bar and a diverse programme of concerts, festivals, book launches and film screenings. With cheap tickets on the door, it's worth dropping in even if you've never heard of the band playing (and you probably won't have).

18-22 Ashwin Street, E8 3DL
cafeoto.co.uk

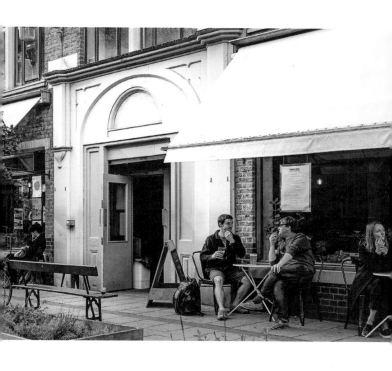

-63-

WILTON'S MUSIC HALL

Theatre and concert hall

After a four-year restoration project costing £4 million, the stage lights came back on in 2015 at the world's oldest surviving grand music hall. The renovations haven't plastered over the crumbly charm of this gem in a quiet Aldgate backstreet, which hosts an impressive line-up of fringe theatre, music, cabaret, workshops and tours. Get down well before doors to soak up some East End history (and a pre-show drink) in the gorgeous Georgian Mahogany Bar.

1 Graces Alley, E1 8JB
wiltons.org.uk

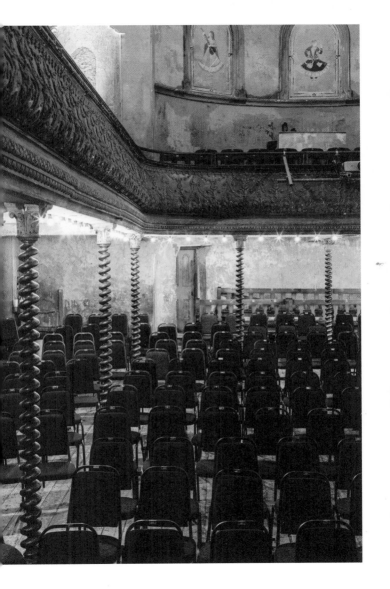

-64-

MOTH CLUB

Music venue

This revamped army serviceman's club is the perfect combination of old and new East London: a classic British institution given a hip upgrade. Many of the original furnishings remain, except now there's a gold glittery ceiling that's worth a visit alone. With an events line-up that riffs on traditional members' club entertainment – gigs, bingo, karaoke, club nights, film screenings and cabaret – there's something fun every night.

Old Trades Hall, Valette Street, E9 6NU
mothclub.co.uk

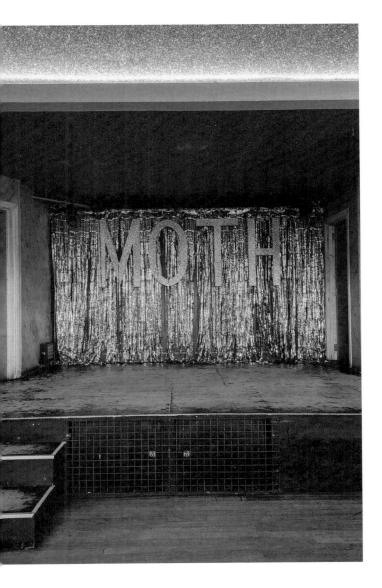

-65-

THE CASTLE CINEMA

Cinema

In 2016, a plucky local couple crowdfunded an impressive £57,000 to restore the derelict cinema above a posh Spar supermarket to its former glory. East Londoners can now enjoy a mix of new releases, arthouse flicks and old classics at this thriving neighbourhood picturehouse, along with a plush 1920s Hollywood-style bar for post-film analysis.

64-66 Brooksby's Walk, E9 6DA
thecastlecinema.com

-66-

RUBY'S

Bar

A retro cinema sign above what was once Ruby House 3 Chinese takeaway reveals a doorway to a judiciously discreet underground cocktail bar and lounge. The soft lighting, exposed brickwork and killer chilli apple martinis are perfect for cosy meet ups. For those who want to really party, the kind people at Ruby's keep the spacious subterranean lounge open late at weekends for drinking and dancing.

76 Stoke Newington Road, N16 7XB
rubysdalston.com

East London: An opinionated guide
Second edition, first printing

First published by Hoxton Mini Press, London 2019
Copyright © Hoxton Mini Press 2019
All rights reserved

Compiled by Hoxton Mini Press
Written by Sonya Barber

All photographs © Charlotte Schreiber except for:
Image for Nude Espresso © Laura Zepp
Images for Pavilion, Bistrotheque, E. Pellicci, Rochelle Canteen and Crate
Brewery © Helen Cathcart
Image for London Fields Lido © Madeleine Waller
Image for Café Oto © Dawid Laskowski
Image for Maureen Paley © Maureen Paley, 2016,
(Image credit: Wolfgang Tillmans, *The State We're In, A.*)
Image for the Clowns' Gallery-Museum © Luke Stephenson
Images for Pam Pam and Haus © David Post
Image for The Castle Cinema © Rick Pushinsky
Image for Jidori © Aaron Tilley
Image for The Ned © The Ned
Image for Bonds © Bonds

East London: An opinionated guide (2017) was designed by Matthew Young.
Revisions for this updated version were made by Hoxton Mini Press.
Copyedited and proofread by Harry Adès and Hoxton Mini Press.

The content and information in this guide has been compiled based on
facts available at the time of going to press. We strongly advise you to check
each location's website before visiting to avoid any disappointment.

Printed and bound by 1010, China

ISBN: 978-1-910566-45-9

FSC
www.fsc.org

MIX
Paper from
responsible sources
FSC® C016973